American Snapshots

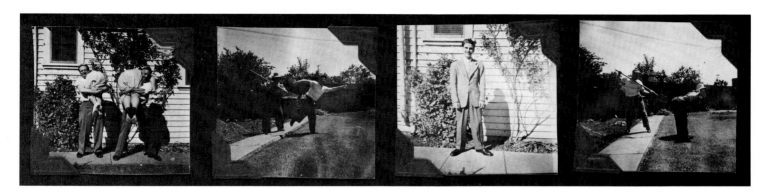

Selected by

Ken Graves & Mitchell Payne

Introduction by Jean Shepherd

The Scrimshaw Press
1977

Acknowledgments

This project was inspired by the family snapshots of Nettleton and Mildred Payne, Robert and Mildred Graves, and William and Paula War, and is dedicated to these families.
We are grateful to the following organizations for their support and assistance:
The National Endowment for the Arts; The National Association of Retired Federal Employees (Chapter #65); and the Senior Citizens of San Francisco.
Special thanks to Harry Bowers, Terry Toedtemeir, Chris Rauchenberg, Minnette Lehmann, and Paula Graves for their help, suggestions, and criticism;
and to the hundreds of families who shared their snapshots with us.

Library of Congress Cataloging in Publication Data
Main entry under title:

American snapshots.

1. Photography, Instantaneous. 2. Photography—United States. I. Graves, Ken, 1942- II. Payne, Mitchell, 1944-
TR592.A43 779'.092'2 77-21861
ISBN 0-912020-64-4

The Scrimshaw Press
6040 Claremont Avenue
Oakland, California 94618

Introduction by Jean Shepherd

DON'T EVER LET this book, this definitive collection of twentieth-century American folk art, get out of your hands. I say this for two very good reasons. First, it is a touching, true, Common Man history of all of us who grew and lived in America in this century, in addition to being very funny and highly informative. Second, it is a collection that will grow in value, both historically and intrinsically, with each passing year.

When Ken Graves and Mitchell Payne conceived the idea of going from door to door and asking to see people's home snapshots, they had no idea what they would find. For the most part, people were delighted that anyone would actually *want* to see their picture of the forty-seven walleyes that Ernie caught at Rifle Lake in 1939. It is a fact of life that we rarely submit willingly to the ordeal of examining other people's pictures. Here were two intelligent men volunteering for the task, armed with a National Endowment for the Arts grant to make it official. I approve of Ken Graves and Mitchell Payne, as well as that blessed grant. It is a project that has been needed for a long time and I think it will prove to have resulted in a collection of pictures that will persist. Not only that, it took great courage and persistence to wade through what must have been a sea of family dogs and pet bunnies. We owe them much.

The very anonymity of the collection of American types which parade through these amateur snapshots is, to me at least, an asset. Mother, Father, The Kids, The Clown; they are all here, caught in the act by that great social force that George Eastman of Rochester created in the 1880s.

It would be almost impossible today to locate a human being in America who has not been photographed. We belong to a generation of humanity that has the power to freeze its image for all time. Cameras have become so sophisticated and automatic that I foresee the day when one will hit the market which loads itself with film, perhaps even manufacturing it in its own little belly, refuses to take pictures that are not artistically "correct," processes the results (giving you a choice of enlargement sizes), and can be

sent to the picnic at the beach alone, thereby relieving the owner of the boring responsibility of fooling around in the sand, eating burnt hot dogs, and getting a sunburn. The sad but inevitable result of our advancing technology has been the decline of fun in actually taking pictures and looking at them. A few years back, and it wasn't that long ago, taking pictures was always something of an event. Everyone trooped out into the backyard to stand next to the garage, squinting into the sun, while Chester or Martha struggled with the camera, usually winding up with a picture that cut off the tops of all heads or hacked everyone off at the kneecaps. Nevertheless, there was great joy in it, except for the inevitable aunt who always claimed "I never look good in pictures," implying, of course, that she looked good in the flesh.

Of all the world's photographers, the lowliest and least honored is the simple householder who desires only to "have a camera around the house" and to "get a picture of Dolores in her graduation gown." He lugs his primitive equipment with him on vacation trips, picnics, and family outings of all sorts. His knowledge of photography is about that of your average chipmunk. He often has trouble loading his camera, even after owning it for twenty years. Emulsion speeds, f-stops, meter readings, shutter speeds have absolutely no meaning to him, except as a language he hears spoken when, by mistake, he wanders into a real camera store to buy film instead of his usual drugstore. His product is almost always people- or possession-oriented. It rarely occurs to such a photographer to take a picture of something, say a Venetian fountain, without a loved one standing directly in front of it and smiling into the lens. What artistic results he obtains are almost inevitably accidental and totally without self-consciousness. Perhaps because of his very artlessness, and his very numbers, this nameless picture-taker may in the end be the truest and most valuable recorder of our times. He never

edits; he never editorializes; he just snaps away and sends the film off to be developed, all the while innocently freezing forever the plain people of his time in all their lumpishness, their humanity, and their universality.

Now, a personal note. I'm sure every person who reads this has his own memories of his private picture-taking career. I remember my first camera, which was a birthday present on the historic tenth anniversary of my earthly debut. In fact, I still own it. It is a tiny camera called a Univex (Model AF-2). It uses a special film size, now unavailable, naturally, and is a tiny camera "perfect to carry in one's vest pocket." It was the forerunner to today's Minox miniature camera. Getting it was the high point of my life up to then. I worked night and day cutting lawns and cleaning basements to earn money for film. Several pictures I took with the Univex still survive. There is one of my father polishing the hood of his 1940 Pontiac Silver Streak. Both he and the car are long gone, but that little 2¼ by 3¼ enlargement remains, a bit blurry but a very real vestige of my personal past. I have since owned Leicas and Nikons, Rolleis and Voightlanders, but no camera ever gave me the pleasure, nor inadvertently recorded as much history, as my first Univex.

We will all have our favorites from among this superb collection of *Humanus Americanus* (common). But how can you separate one from the other? They are all of a piece, each piece part of our own lives, and Graves and Payne, George Eastman, and Uncle Clifford or Aunt Mabel have captured that piece of all of us, for all of us, for now and forevermore, like a tiny high school cheerleader frozen for all eternity.

Jean Shepherd
Washington, N.J. 1977

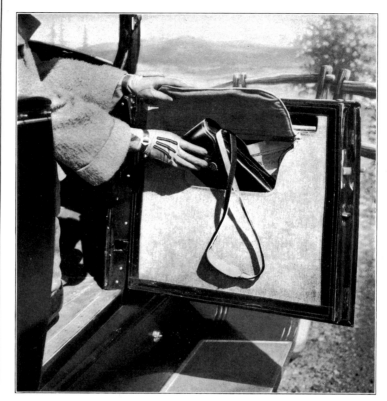

Picture Ahead,

 Kodak as you go

Autographic Kodaks $6.50 up

Eastman Kodak Company, Rochester, N.Y., *The Kodak City*

Authors' Foreword

BILLIONS OF SNAPSHOTS are taken every year in the United States and around the world. People take them in order to celebrate and to remember—birthdays, Christmas, Easter, the Fourth of July; pets, new cars (with the proud owner in, on, or next to the vehicle); first communions, fishing and hunting trophies; people on vacation in front of monuments; new marriages and new babies. They seem to record what they want to remember, never that which they do not. They glue these snapshots into albums and send duplicates to relatives and shuffle the rest off into bedroom closets.

But we very much enjoyed looking at our own families' photographs, and while looking through our parents' and grandparents' albums we saw a number of pictures which deserved some sort of special consideration. A few transcended the boundaries of the ordinary and carried an integrity and life of their own. We thought that these images could exist outside the family albums and if there were special examples in *our* family collection, then there were surely thousands in other families.

During a two-year assault, we went door to door, supported in part with a grant from the National Endowment for the Arts, asking unsuspecting householders if we might enter and look through their albums. We pushed hundreds, perhaps thousands, of doorbell buttons, met many barking dogs, were questioned and helped by the police, and were often frustrated in trying to convince people, through locked doors, that we were harmless. But we were often invited in and, once settled, rummaged through thousands of pictures in shoeboxes and black-paged albums, sharing hours of anecdotes and reminiscences. We were on a search for those pictures which were complete visual statements, needing neither explanation nor rationalization. We picked images which were extraordinary for us, relying on our own photographic intuition and sensitivity.

The hundreds of thousands of pictures we saw represent only a tiny percentage of what must exist. There is a vast store of visual wealth spread across this country and we hope that others will tap it in their own way.

Ken Graves and Mitchell Payne

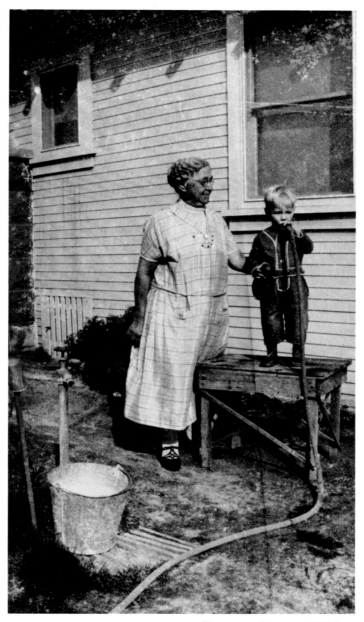

Orange, Texas, 1926.

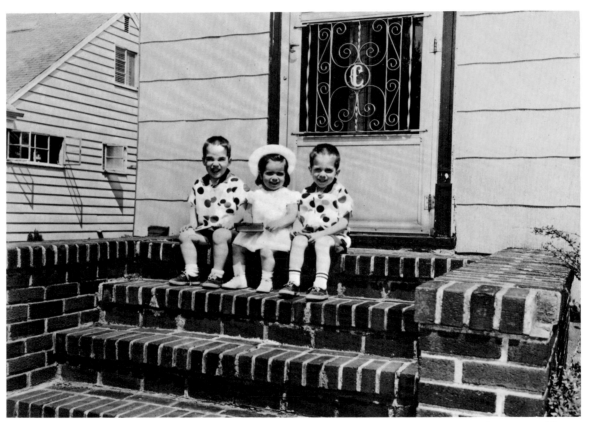

"Easter Sunday," Tenafly, New Jersey, 1964.

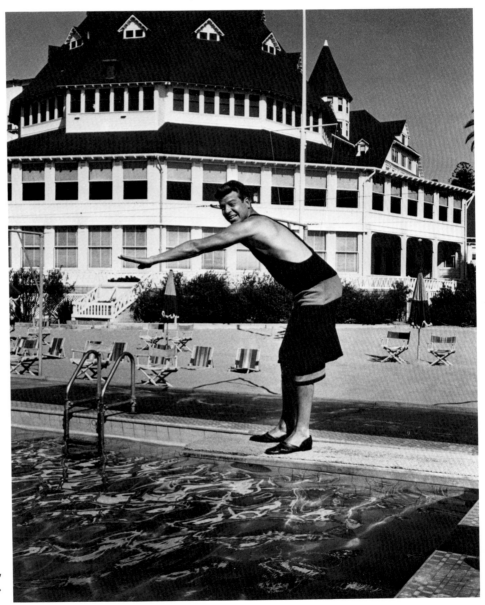

Hotel Del Coronado,
San Diego, California, 1939.

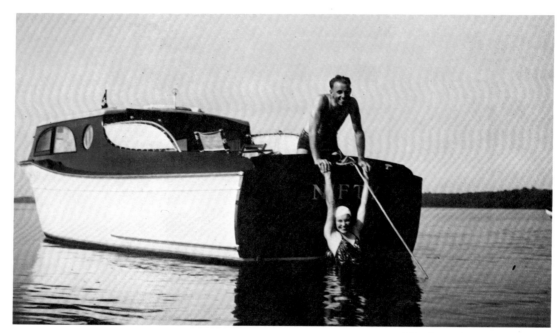

Hudson River, 1941.

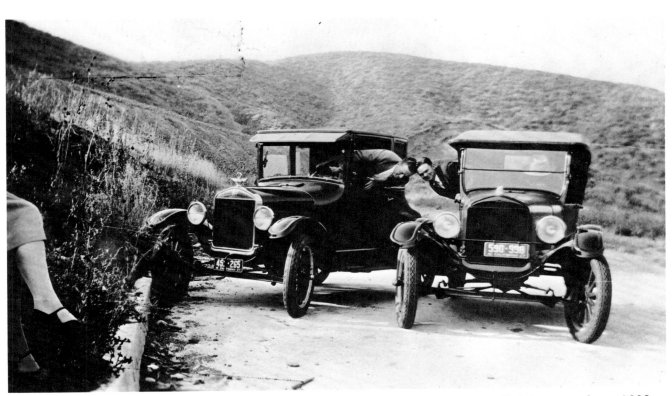

Big Bear, California, about 1920.

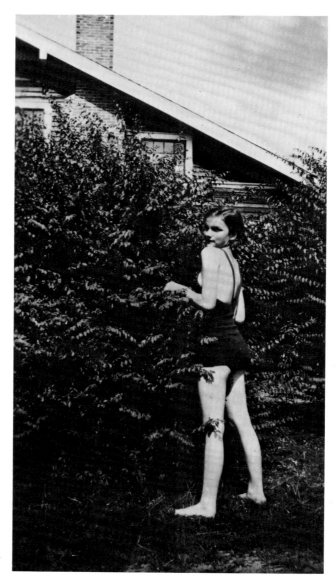

Magee, Mississippi, 1933.

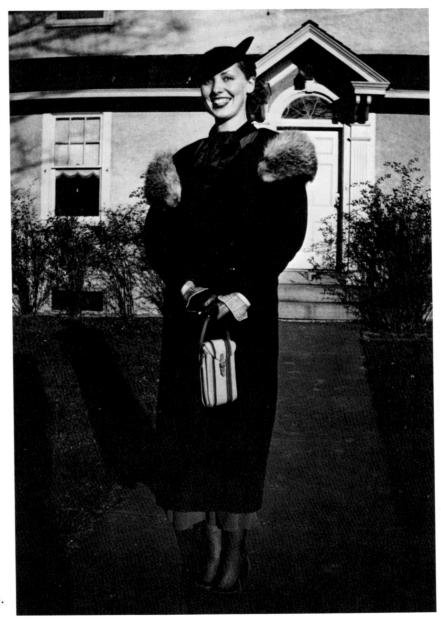

Saugerties, New York, 1933.

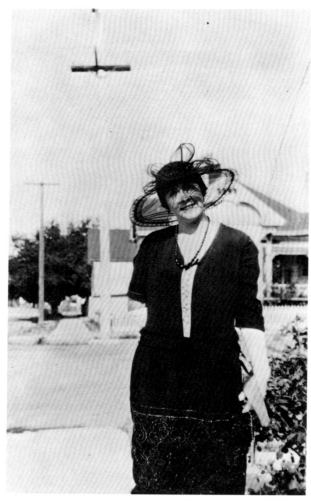

Redwood City, California, 1920.

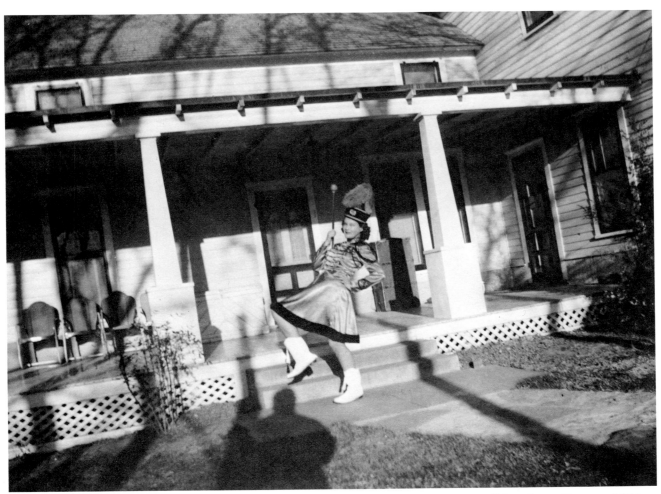

Mendota, Texas, 1944.

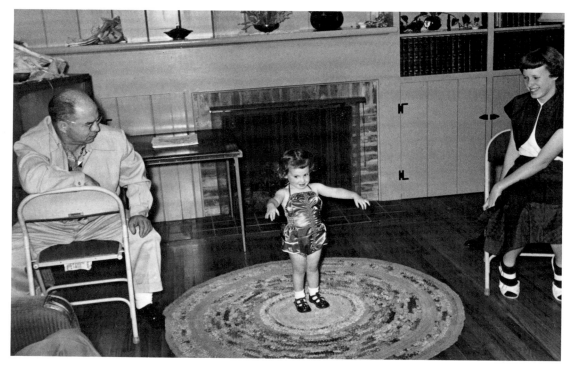

"Birthday party," San Jose, California, 1954.

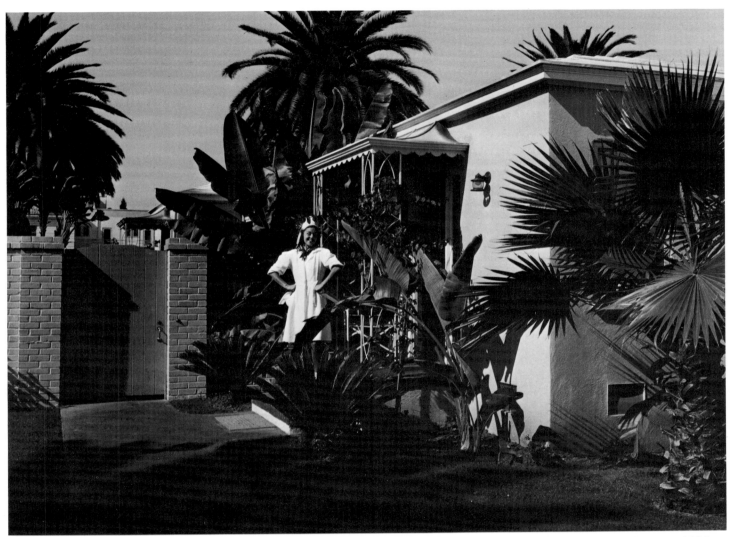

"Honeymoon," Santa Monica, California, 1939.

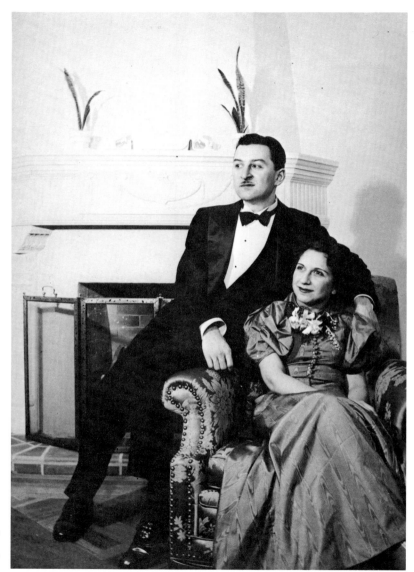

"New Year's Eve, 1937,"
San Francisco, California.

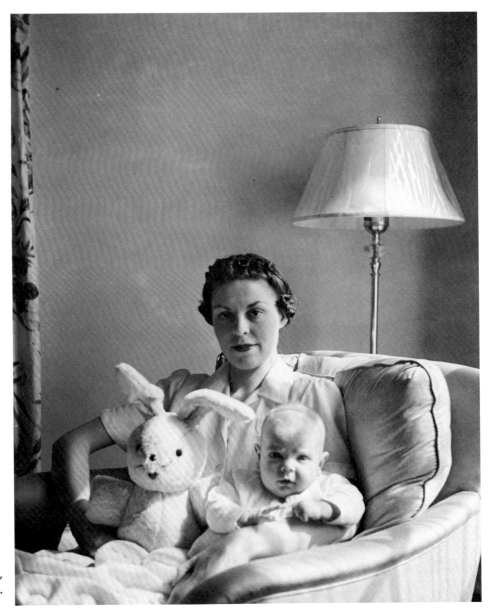

Shawnee Mission,
Kansas, 1941.

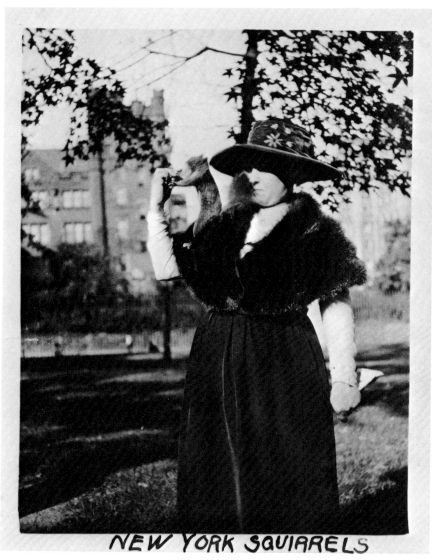

NEW YORK SQUIARELS

Place and date unknown.

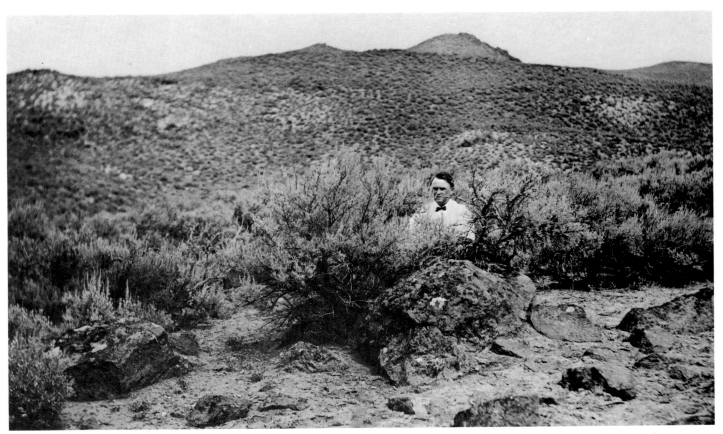

Place and date unknown.

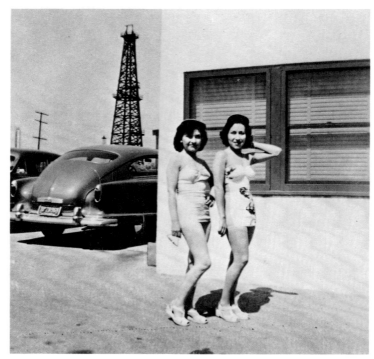

Long Beach, California,
date unknown.

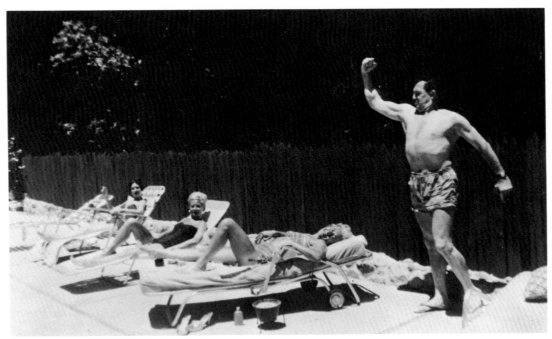

Boulder Creek, California, 1953.

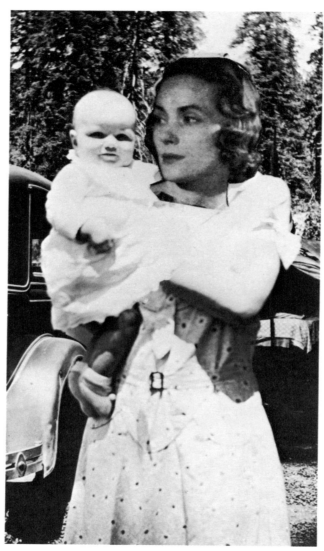

Red Bluff, California, 1930.

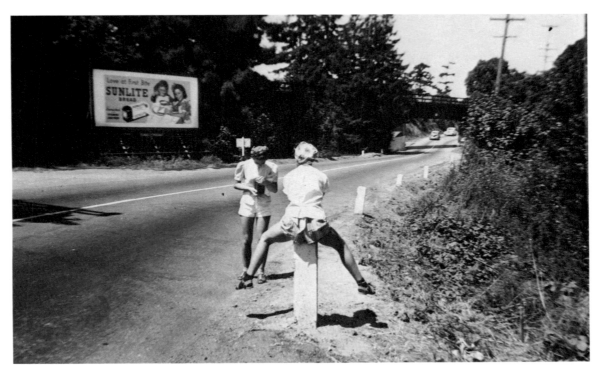

Highway near Aptos, California, 1941.

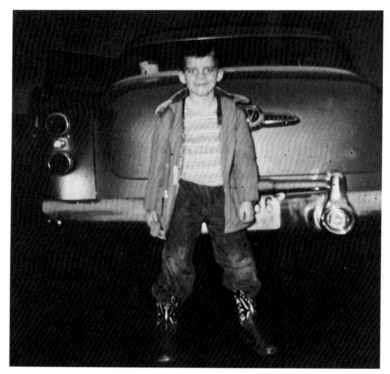

Norwalk, Connecticut, about 1953.

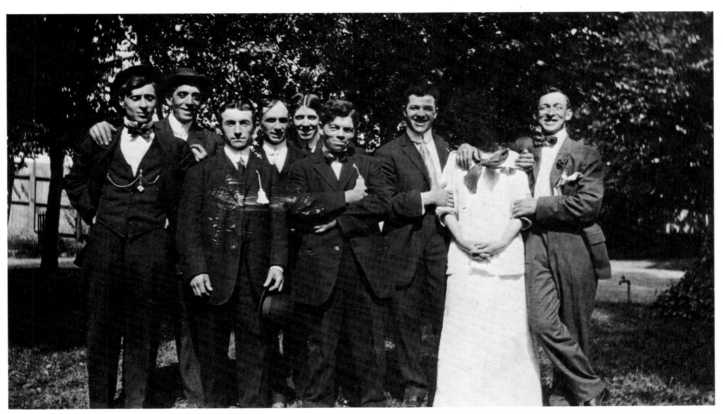

"I had the negative retouched because we thought this girl's parents wouldn't like it— knowing she had been with all those men." Berkeley, California, about 1916.

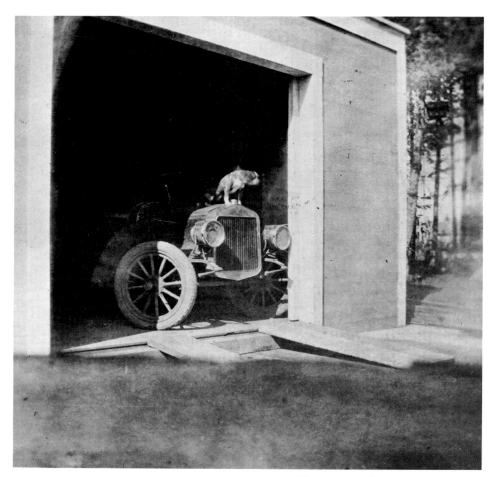

Place and date unknown.

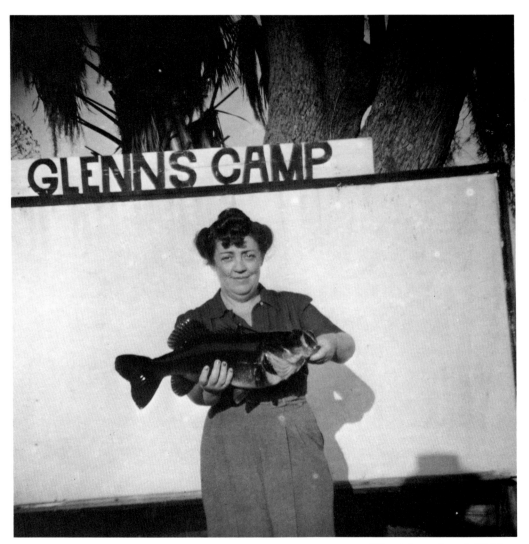

Florida, about 1945.

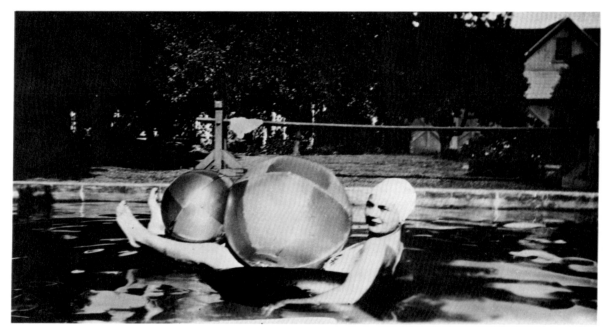

Vacaville, California, 1946.

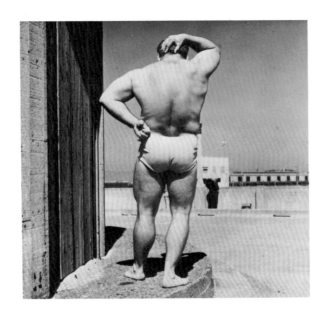
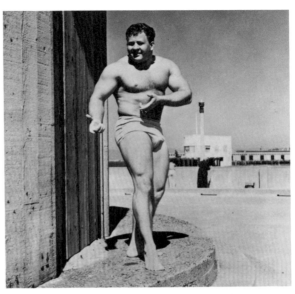
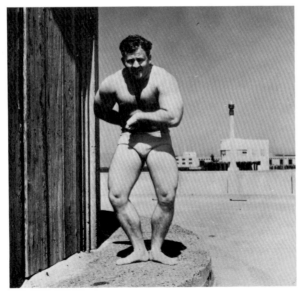
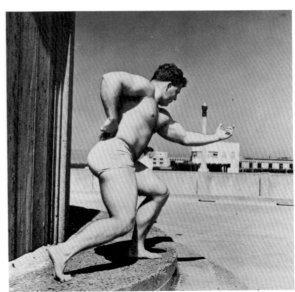

San Francisco, California, 1958.

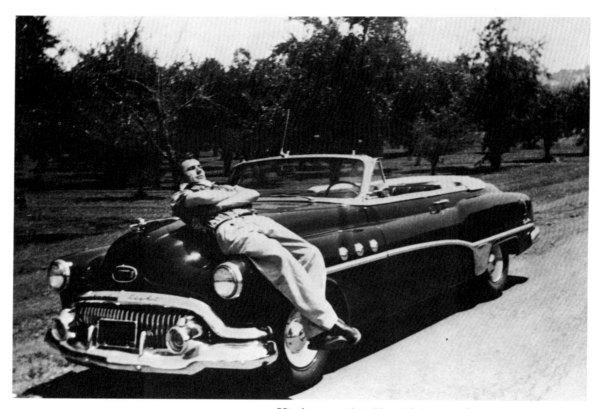

Highway 101, Healdsburg, California, 1952.

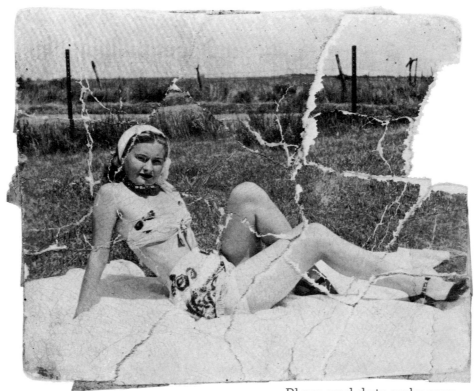

Place and date unknown.

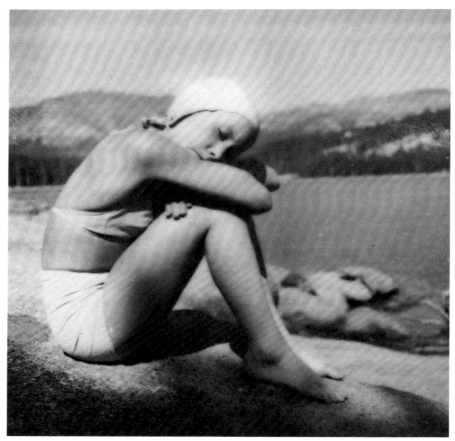

Place and date unknown.

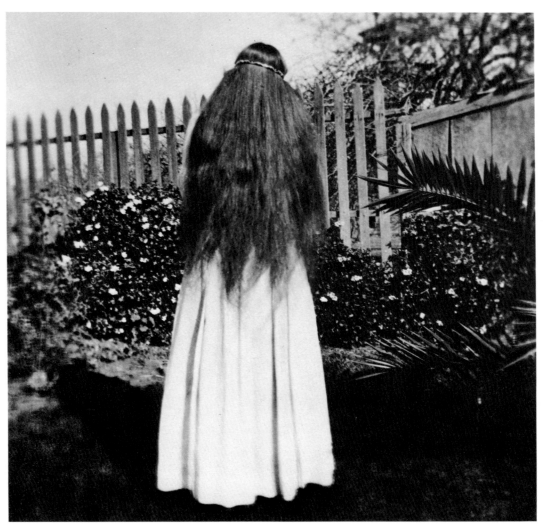

Place and date unknown.

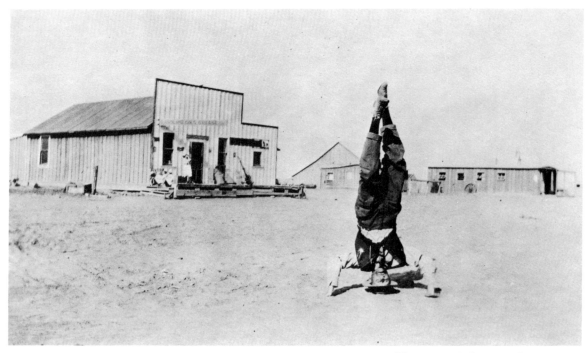

Place and date unknown.

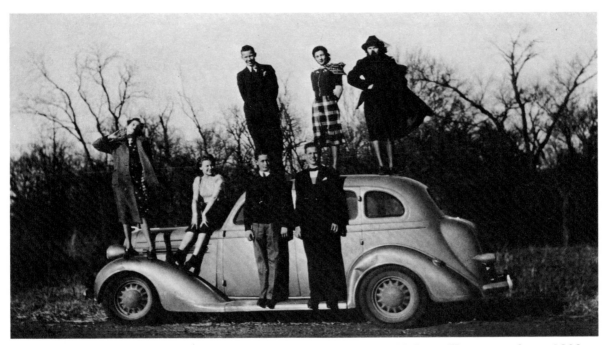

Holton, Kansas, about 1938.

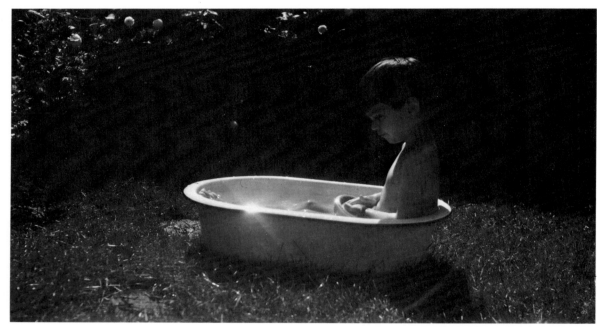

San Francisco, California, 1942.

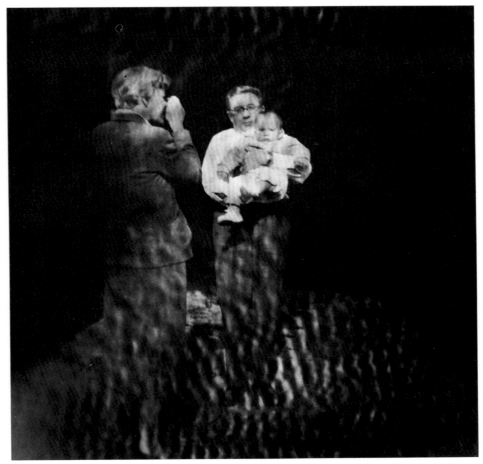

Chevy Chase, Maryland, 1955.

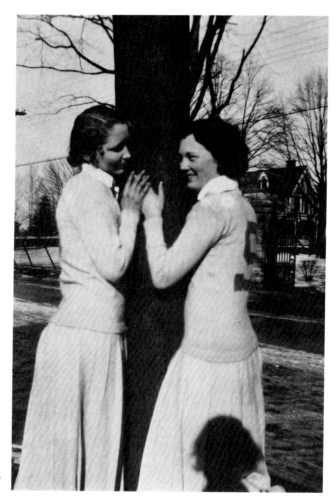

Saugerties, New York, 1934.

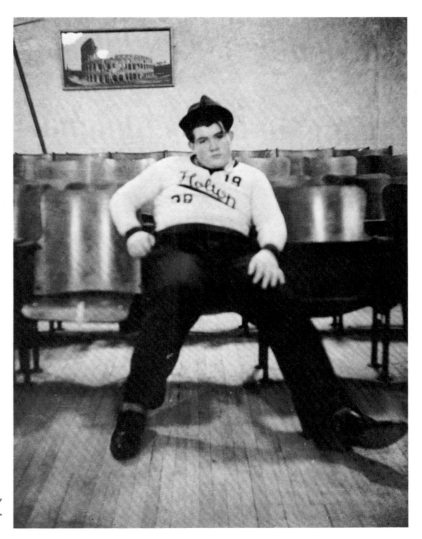

Holton High School,
Holton, Kansas, about 1937.

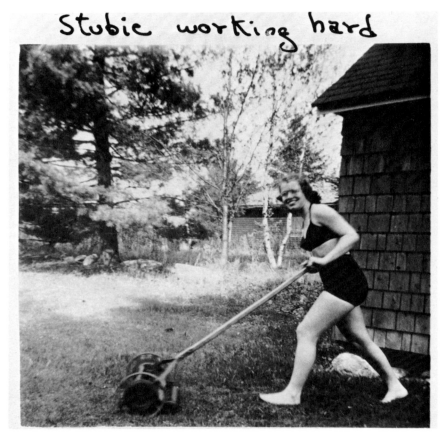

Stubie working hard

Lewiston, Maine, about 1952.

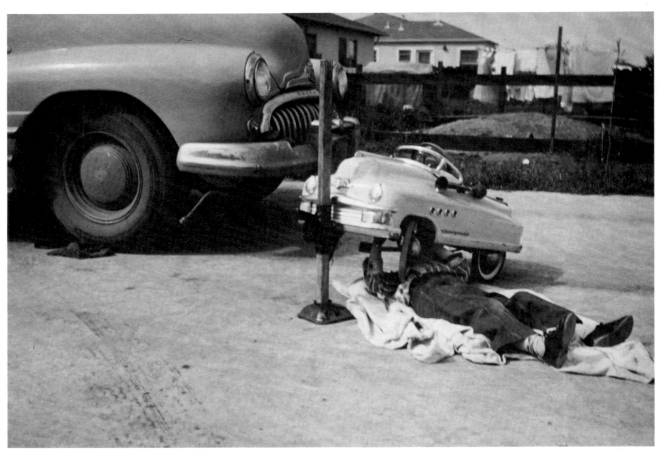

San Jose, California, about 1952.

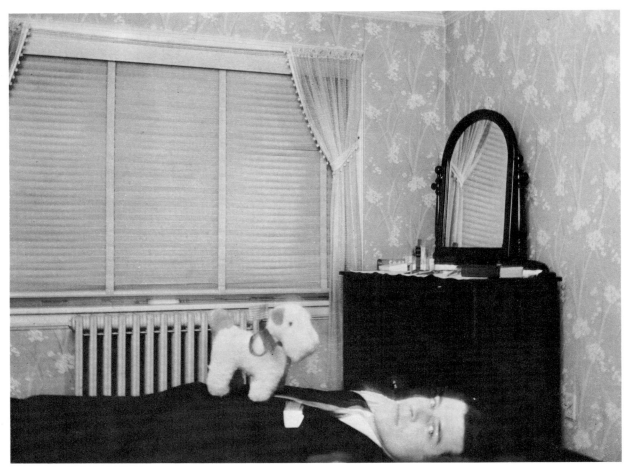

Kansas City, Missouri, 1940.

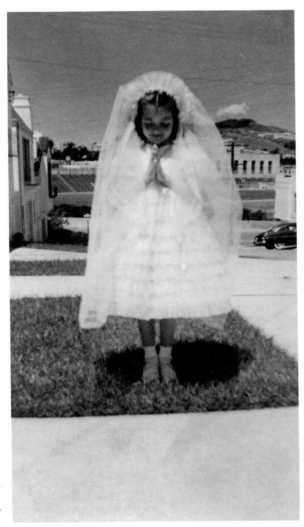

"First Communion,"
San Francisco, California, 1950.

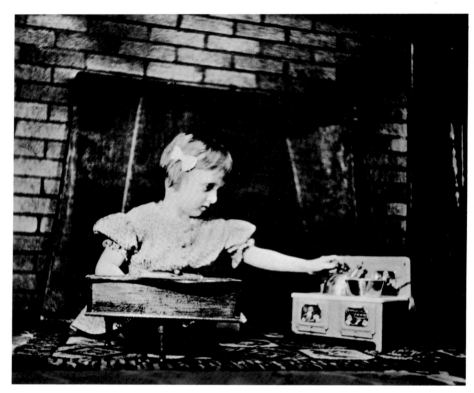

Place and date unknown.

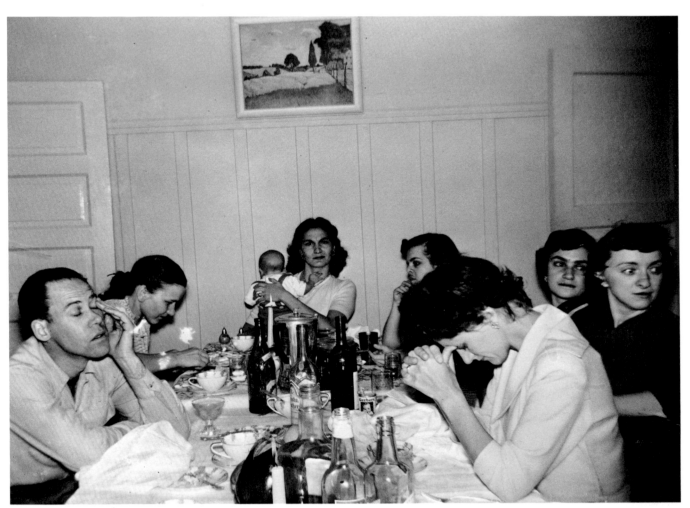

"Thanksgiving Dinner," San Francisco, California, 1952.

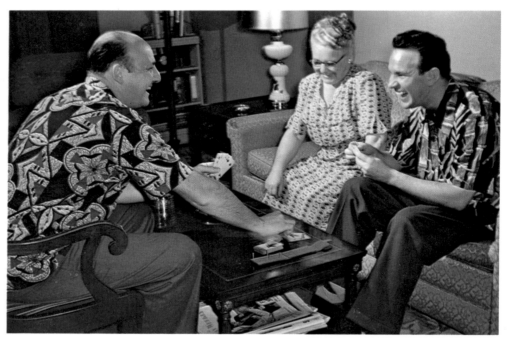

New York, New York, 1955.

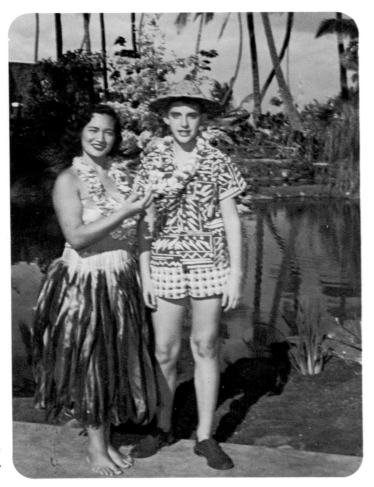

Hawaii Village,
Honolulu, Hawaii. 1956.

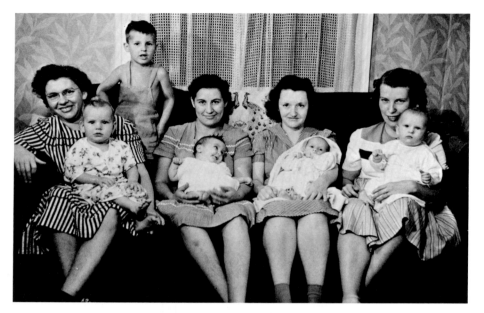

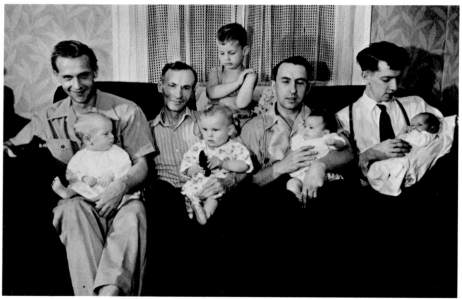

Gresham, Oregon, 1942.

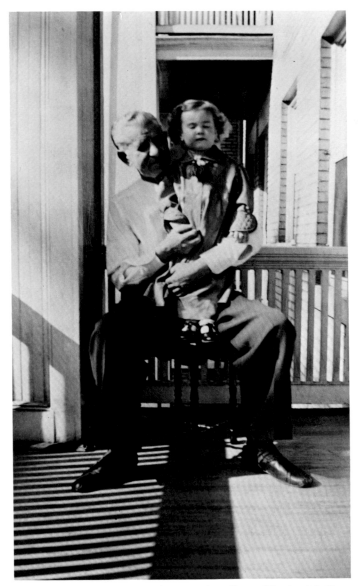

Salt Lake City, Utah, 1949.

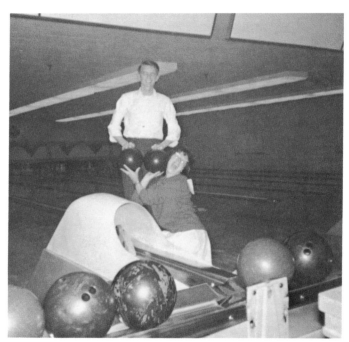

Sacramento,
California, 1963.

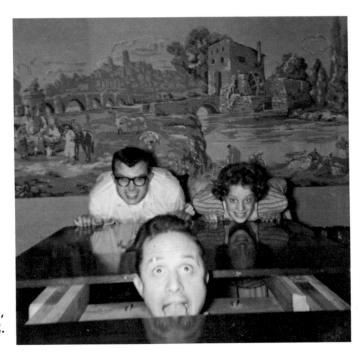

Burlingame,
California, about 1962.

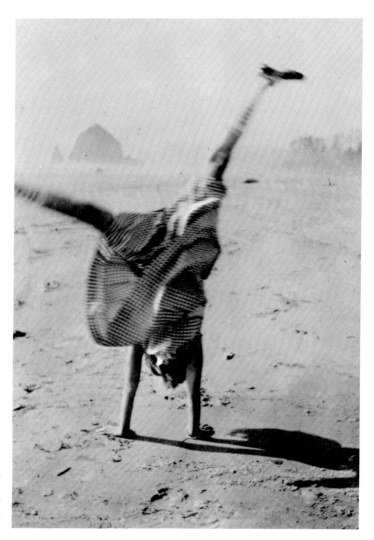

"Haystack Rock,"
Cannon Beach, Oregon,
date unknown.

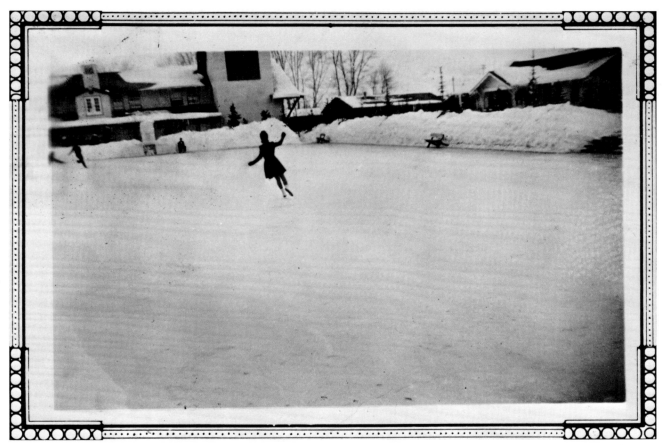

Sun Valley, Idaho, 1942.

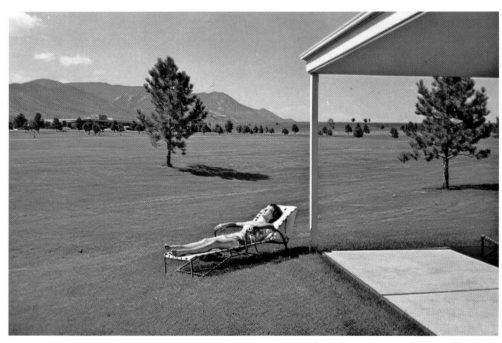

Garden of the Gods Club,
Colorado Springs, Colorado, 1974.

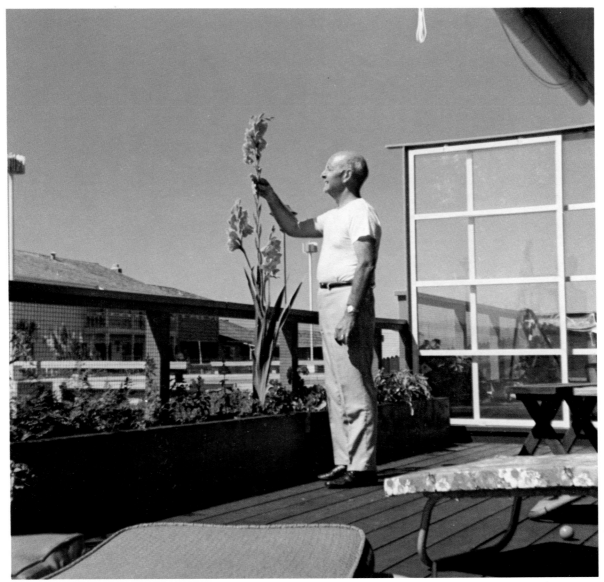

Foster City, California, 1971.

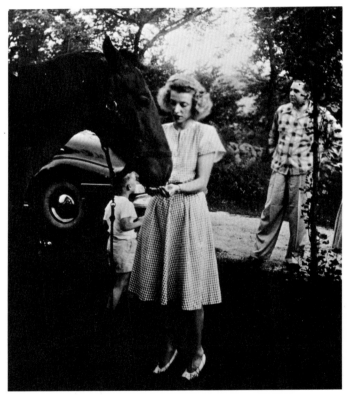

Jackson County, Missouri, 1946.

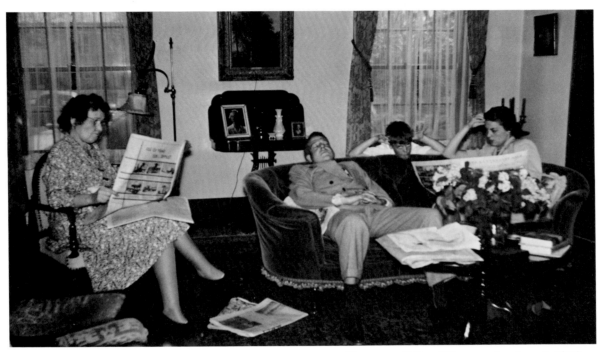

Kansas City, Missouri, about 1948.

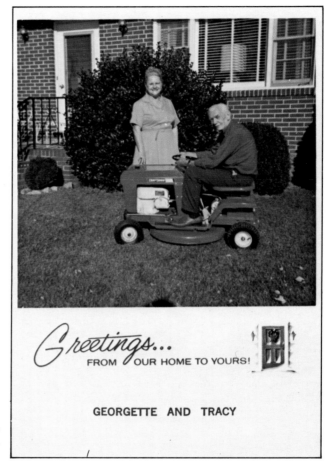

Greetings...
FROM OUR HOME TO YOURS!

GEORGETTE AND TRACY

Williamsburg,
Virginia, about 1959.

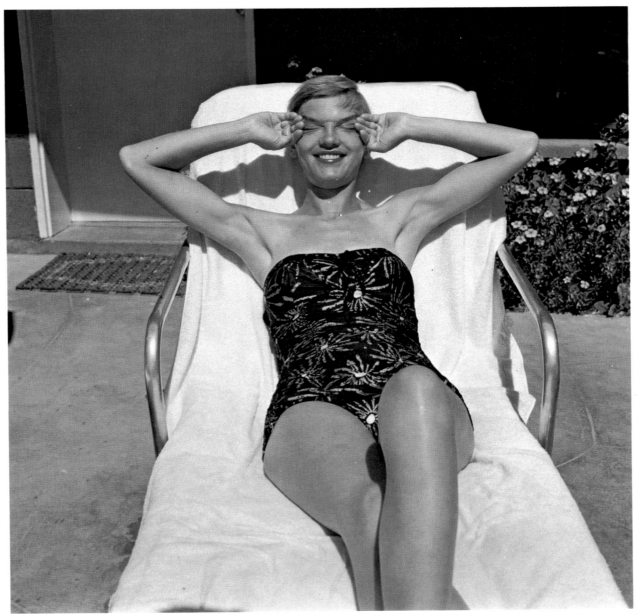

Palm Springs, California, 1957.

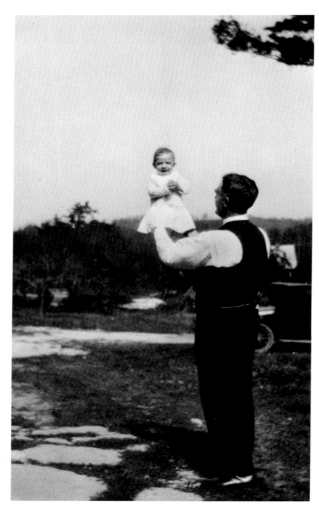

West Camp,
New York, 1929.

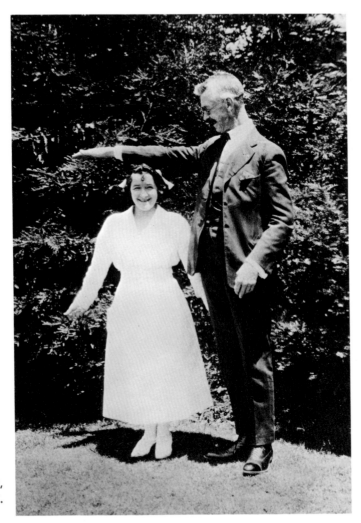

McKinley Park,
Sacramento, California, 1922.

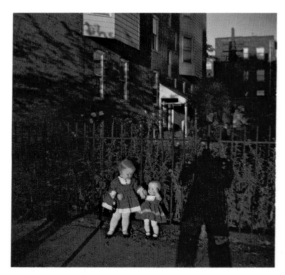

"Easter Sunday,"
Great Bend, Kansas, 1953.

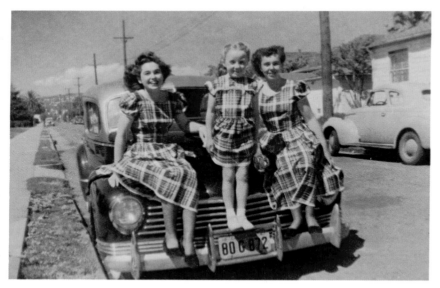

Berkeley, California, 1948.

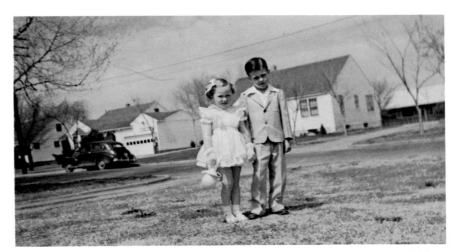

Place unknown, 1953.

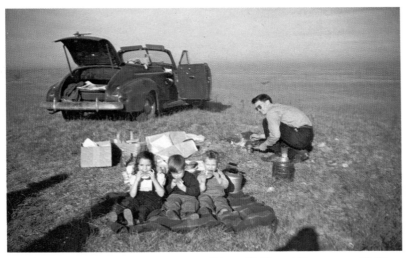

Flint Hills of Kansas, 1947.

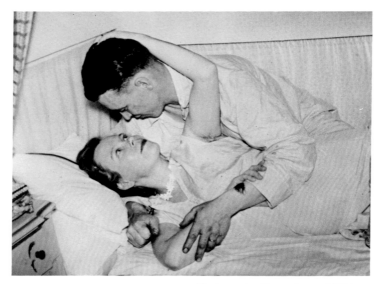

Taken in Sweden, 1954.

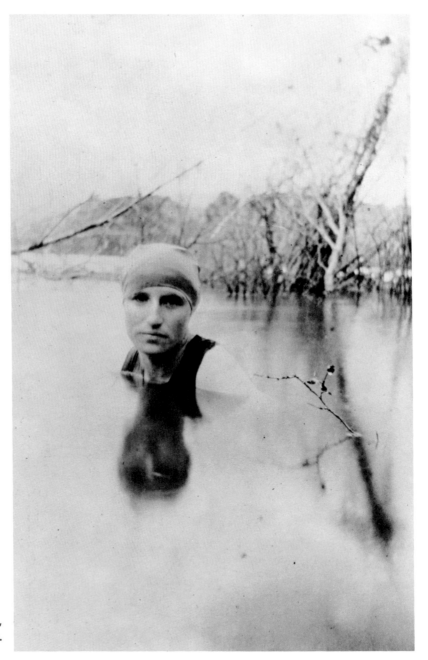

Smith Lake,
Oregon, about 1929.

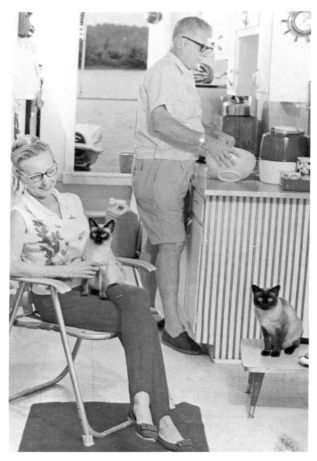

"Hi you all—Marg is coloring up a storm so I'm the Xmas card getter outer. We would sure love to see you all again. But our chances of getting out west are very slim. We have a built in vacation at home as you can see from the pix." Place and date unknown.

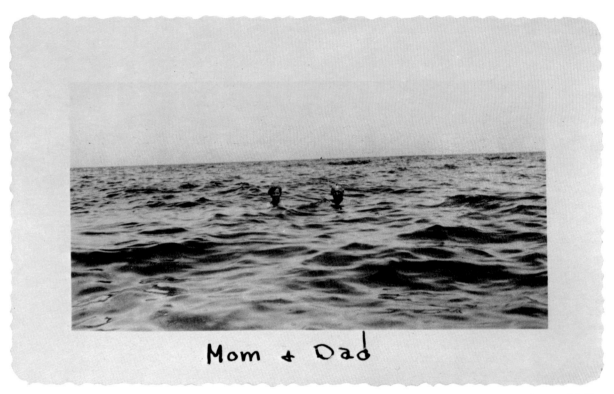

Mom & Dad

Cape Cod, Massachusetts, about 1943.

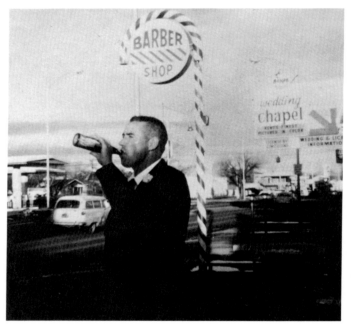

"This is the typical picture of a nervous bridegroom . . . calming down with a Pepsi. 'Junior' was 31 before he decided to take the big step." Reno, Nevada, 1967.

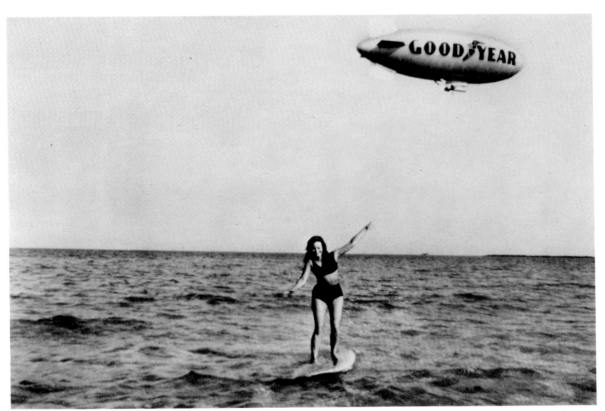

Miami Beach, Florida, 1962.

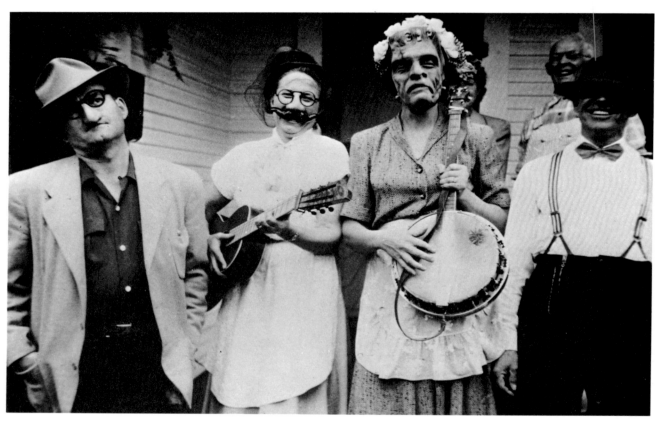

Place and date unknown.

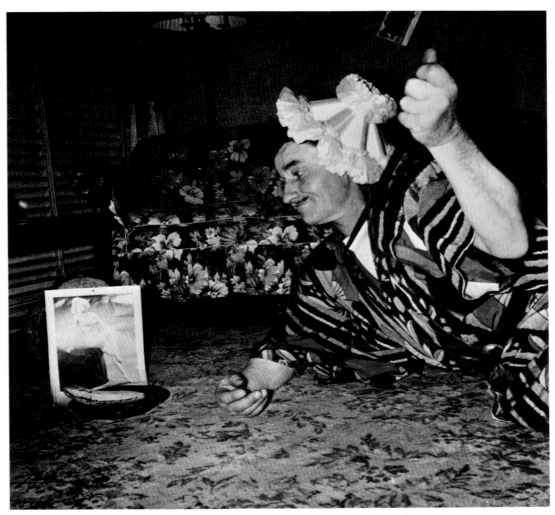

"At a family gathering each person
was asked to do an impersonation
of a Japanese playboy who was
in love with Marilyn Monroe."
Colma, California, 1955.

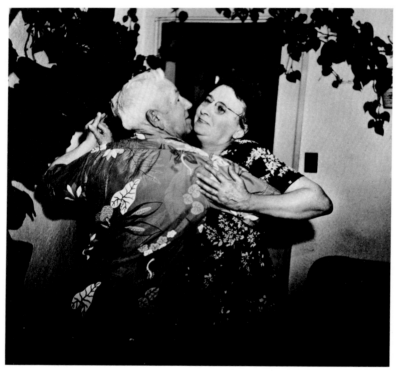

Place and date unknown.

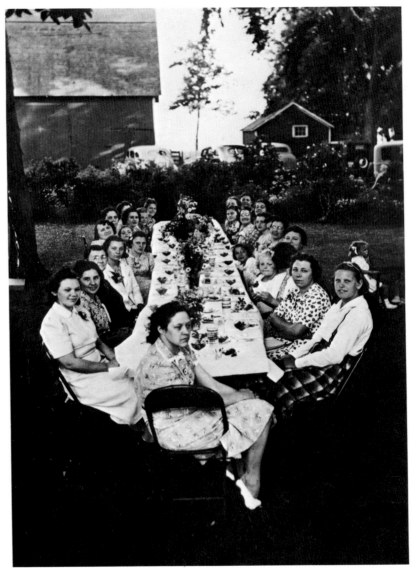

Place and date unknown.

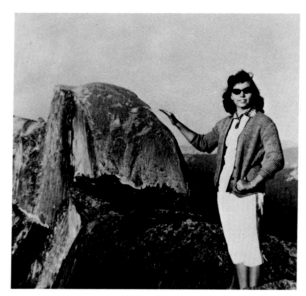

Glacier Point, Yosemite
National Park, California, 1960.

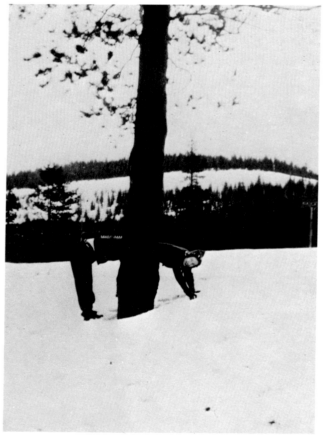

Lake Tahoe, Nevada, 1938.

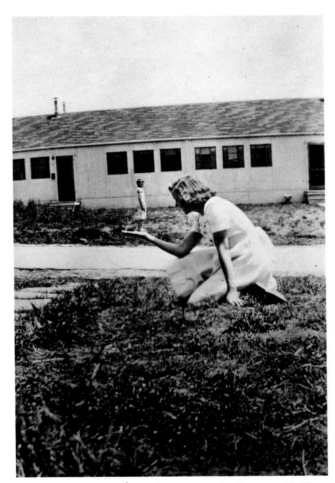

Charlestown, Indiana, 1946.

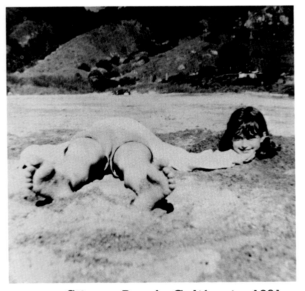

Stinson Beach, California, 1961.

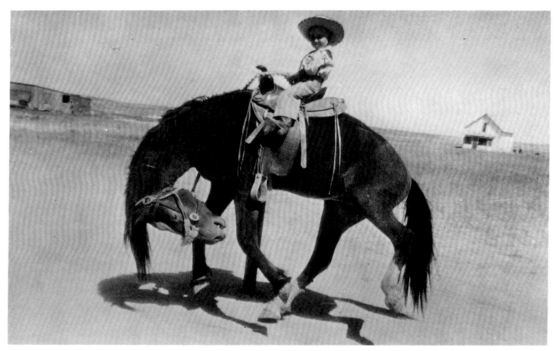

Billings, Montana, 1947.

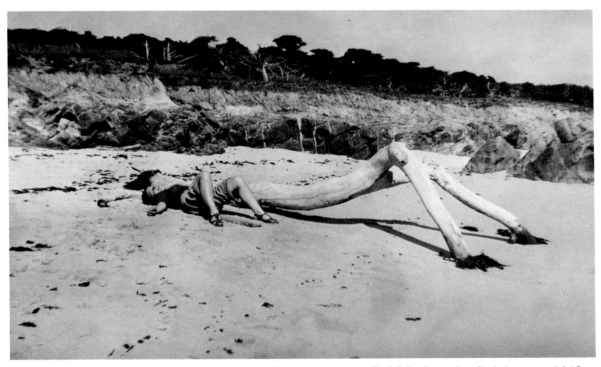

Cypress Point, Pebble Beach, California, 1940.

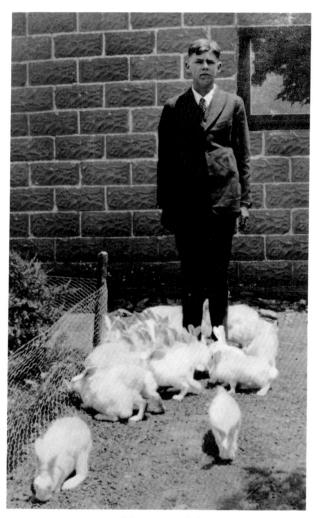

Place and date unknown.

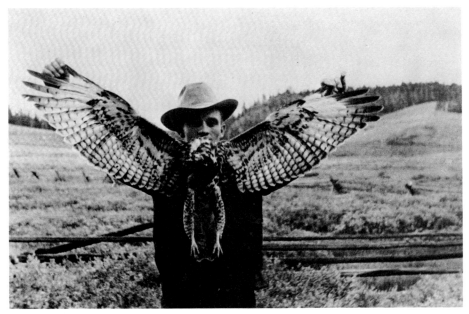

Snowy Range country, Wyoming, 1939.

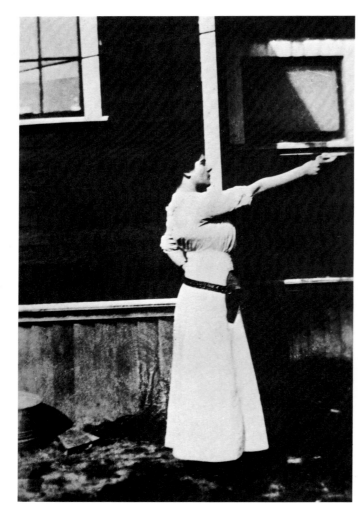

"That day we were on the loose taking pictures. Only occasionally someone who had a camera would come our way and when this happened everyone posed, usually doing things we didn't do everyday. In those days owning a camera was just a sometimes thing, not like now." Bridgeville, California, 1912.

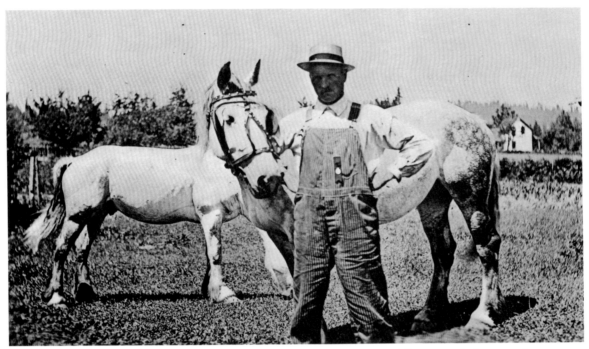

Place and date unknown.

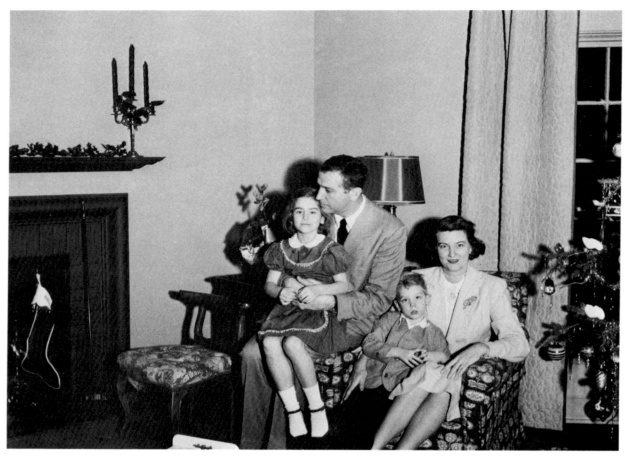

Shawnee Mission, Kansas, about 1946.

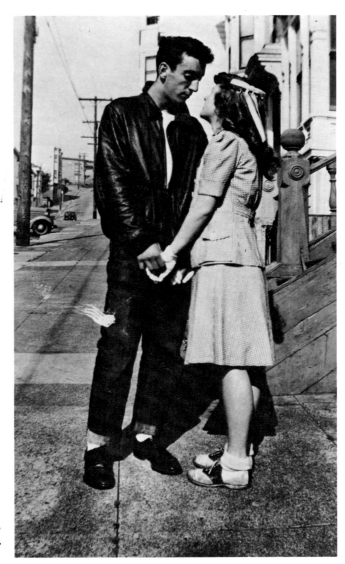

San Francisco,
California, 1946.

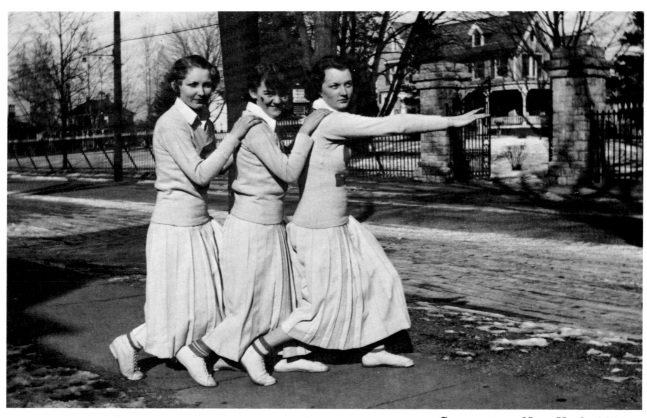

Saugerties, New York, 1934.

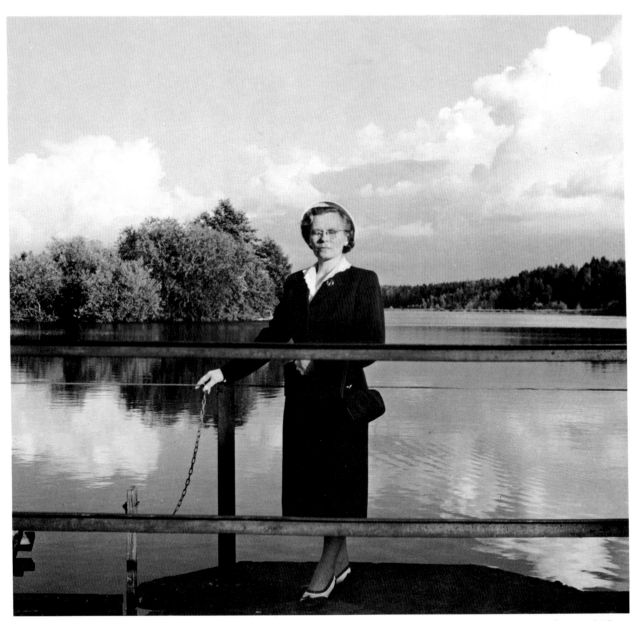

Taken in Sweden, 1952.

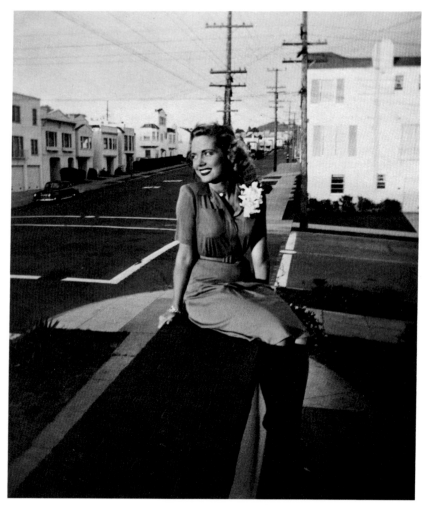

San Francisco, 1947.

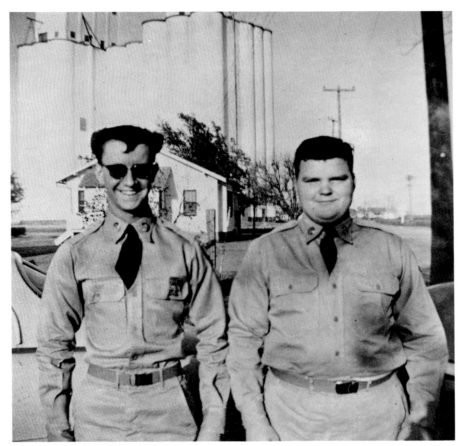

Medford, Oklahoma, 1957.

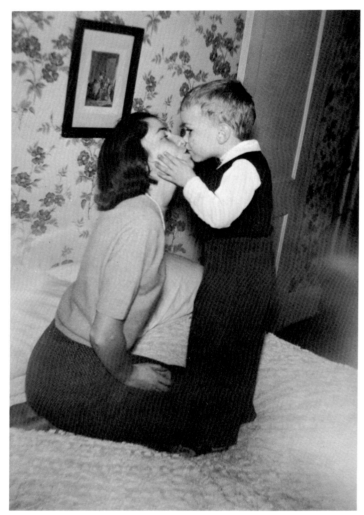

Westport,
Connecticut, 1951.

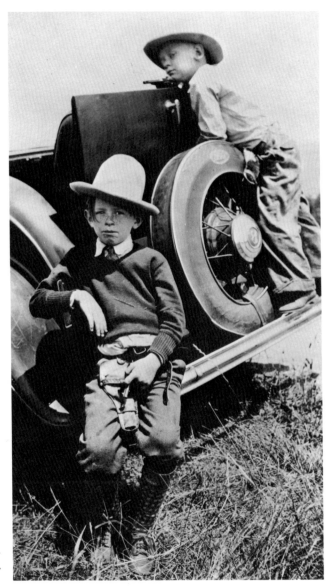

Place and
date unknown.

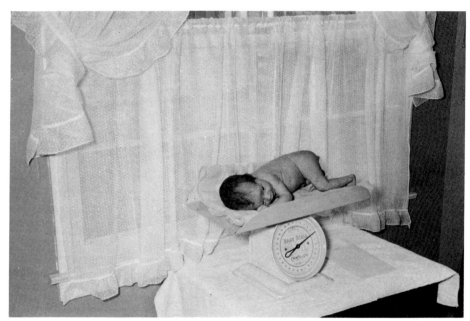

Redding, California, 1952.

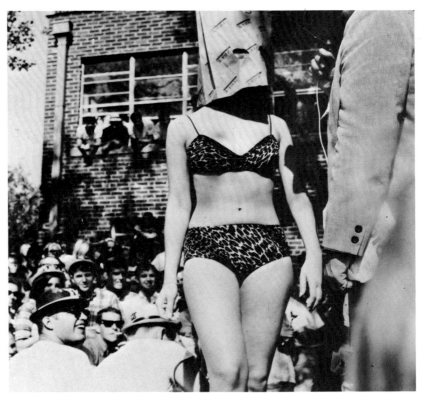

"I was representing my sorority
wearing a swim suit and bag
of my choice." University of
Oklahoma, Norman, 1966.

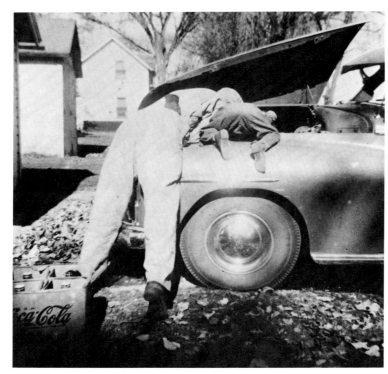

Britt, Iowa, about 1941.

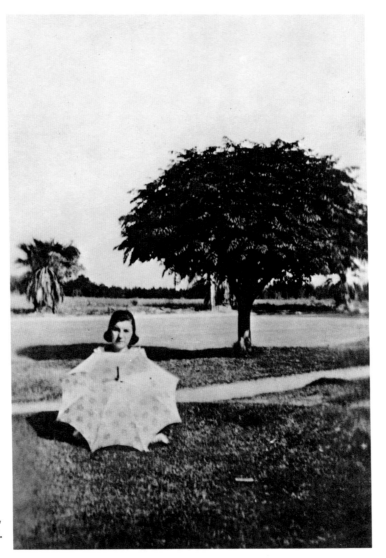

Stanford University,
Palo Alto, California, 1920.

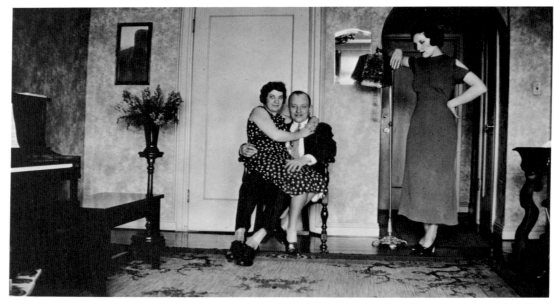

San Francisco, California, about 1933.

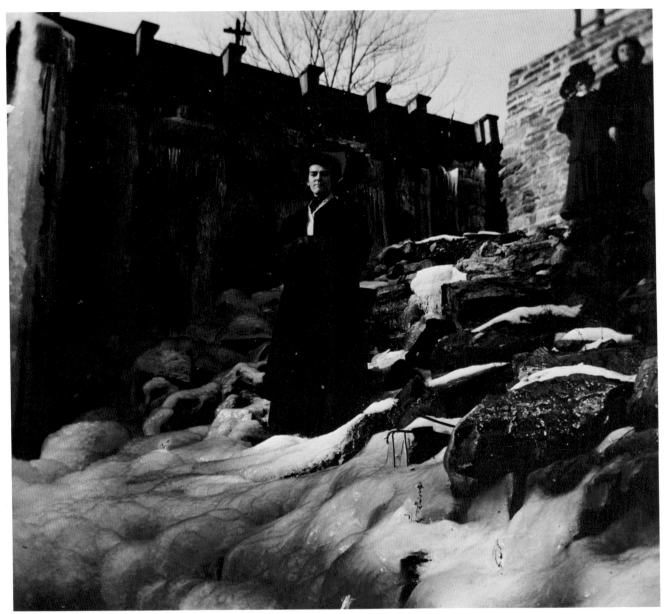

High Falls, Saugerties, New York, about 1910.

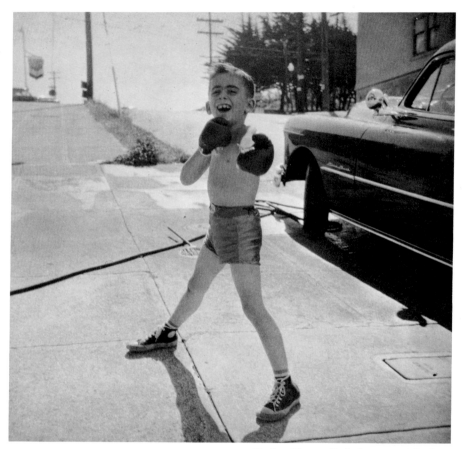

Daly City, California, 1949.

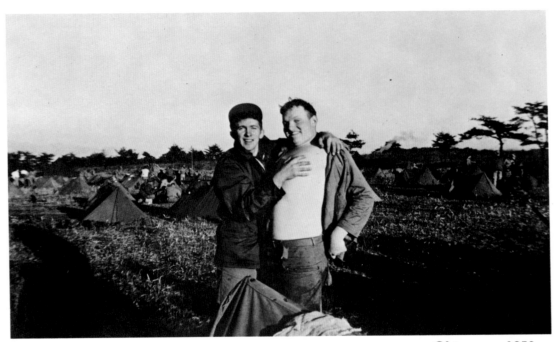

Okinawa, 1953.

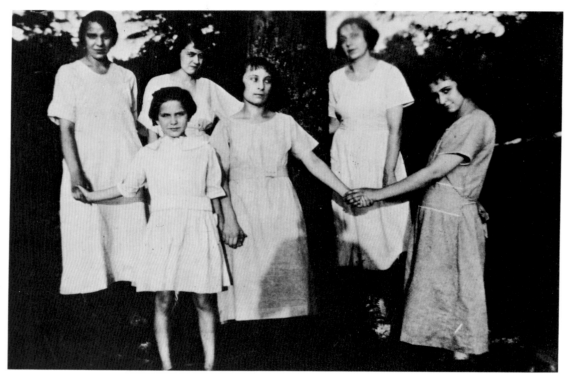

Allentown, Missouri, 1920.

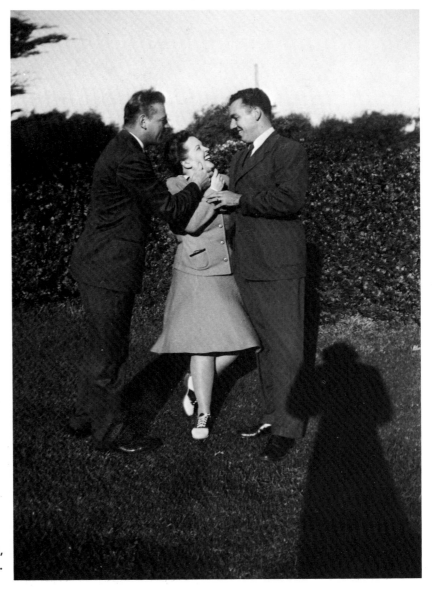

Golden Gate Park,
San Francisco, California, 1941.

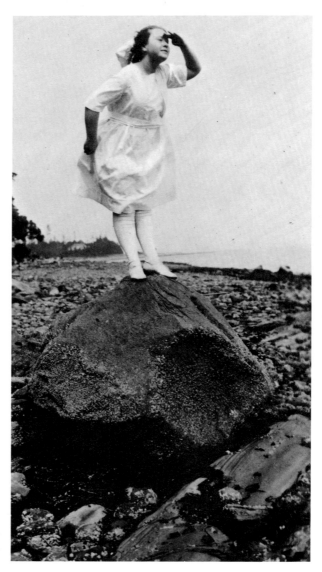

Place and
date unknown.

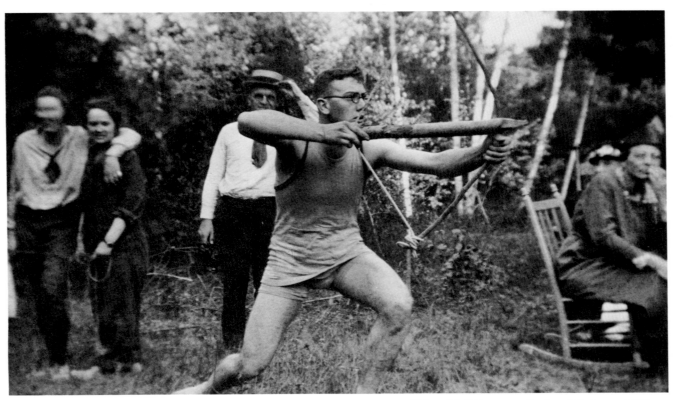

"Cupid," Brewer Lake, Maine, 1921.

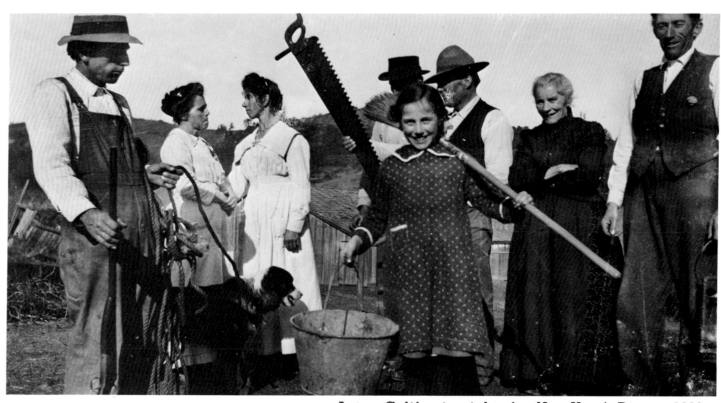

Aptos, California, right after New Year's Dinner, 1920.

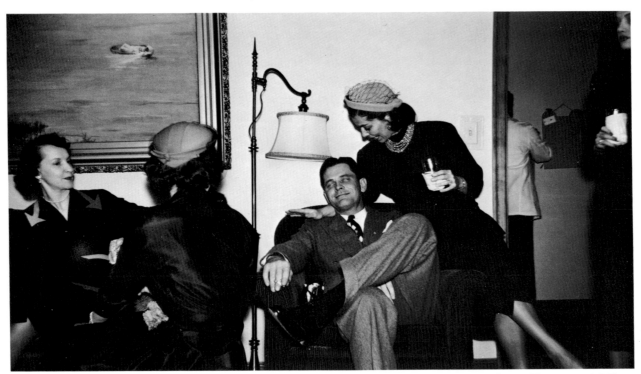

Kansas City, Kansas, 1941.

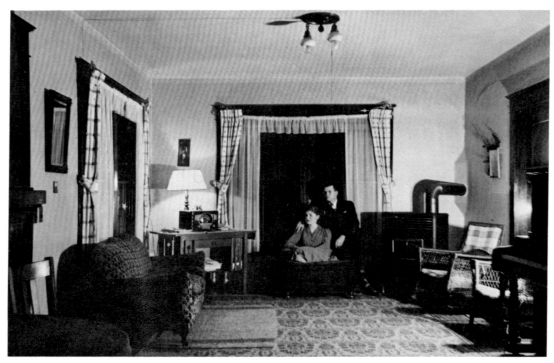

Wrangell, Alaska, 1941.

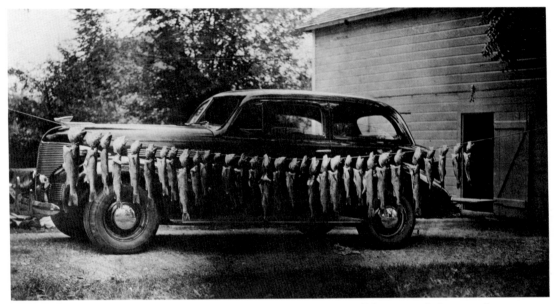

Place and date unknown.

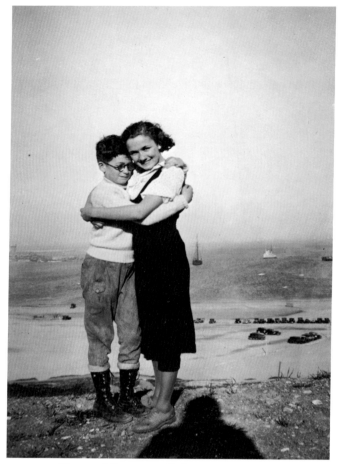

Santa Monica, California, about 1932.

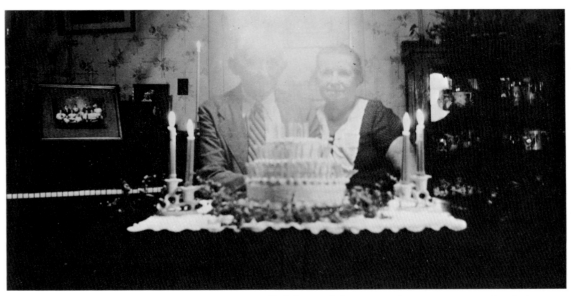

"50th wedding anniversary—took picture
to send to relatives in California."
Crawley, Louisiana, 1936.

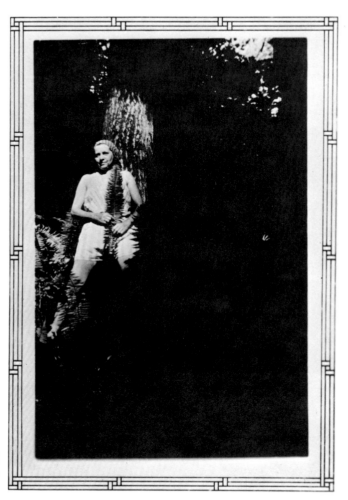

Place and
date unknown.

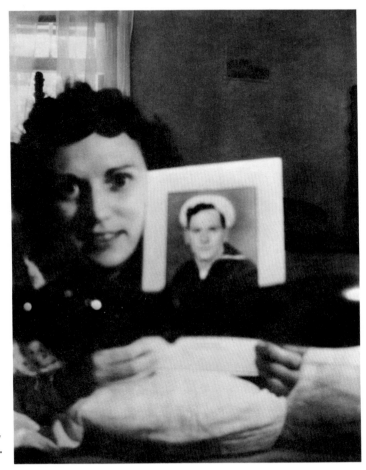

Hilton Village, Warwick,
Virginia, about 1941.

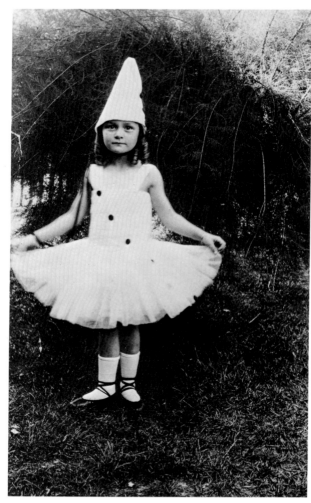

Berkeley, California, 1924.

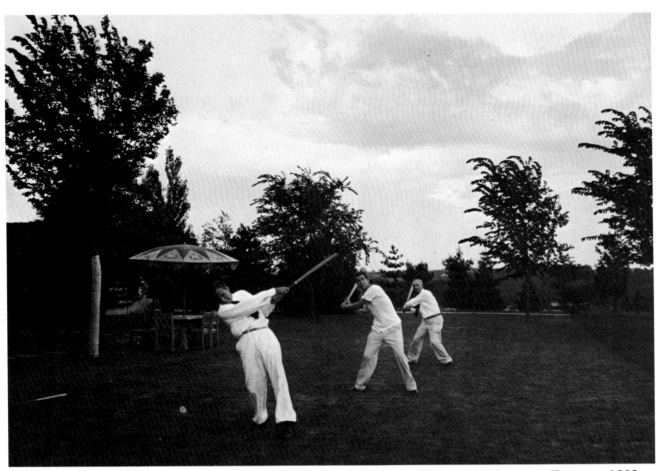

Shawnee Mission, Kansas, 1936.

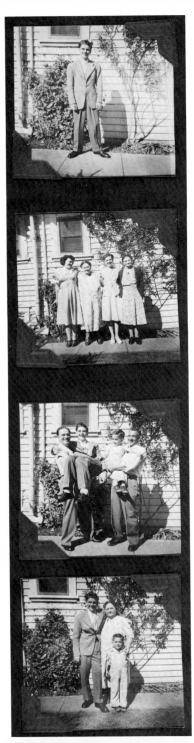

American Snapshots was printed by Cal Central Press in Sacramento and bound by Cardoza-James Binding Co., San Francisco, in August 1977. The paper is Simpson's Shasta Suede.

The type for the text was set in Memphis Medium by Mercury Typography on their V.I.P. Other display type was set by Solotype in Beton and Beton Outline.

The book was designed by Frederick Mitchell and Karen Petersen.